STAFFORD

THROUGH TIME

Anthony Poulton-Smith

AMBERLEY PUBLISHING

Acknowledgements

Martyn Hearson – page 7 top

Rob Strang – page 8 top; page 9 top

Trevor Tupper – page 10 bottom

Mike G. Fell – page 11 top

Nick Macer – page 12 bottom

Swan Hotel – page 13 bottom; page 14 top; page 15 top; page 16 bottom; page 17 top; page 18 bottom

Cliff Homer – page 19 top; page 20 top; page 21 top; page 22 top; page 22 bottom; page 23 top; page 24 top; page 25 top; page 26 top; page 28 top; page 29 top; page 30 top; page 31 top; page 32 top; page 33 top; page 34 top; page 34 bottom; page 35 top; page 35 bottom; page 36 top; page 36 bottom; page 37 top; page 37 bottom; page 38 top; page 39 top; page 39 bottom, page 40 top; page 41 top; page 42 top; page 43 top; page 44 top; page 45 top; page 46 top; page 46 bottom; page 47 top; page 47 bottom

Stafford Cricket & Hockey Club – page 59 top; page 59 bottom; page 60 top; page 60 bottom; page 61 bottom; page 62 top; age 63 top; page 64 top; page 65 bottom; page 66 bottom; page 67 top

Stafford Grammar School – page 68 (1) top; page 68 (2) bottom; page 69 top (1 & 2)

The Soup Kitchen – page 70 top (1 & 2); page 70 bottom

John Sutter Collection – page 71 top

Captain Frank W. Kazmer – page 72 top

Edward Dobson – page 27 top; page 68 top (1 & 2); page 68 bottom; page 73 top; page 74 (1) top; page 74 (2) top; page 75 top

Terry Godridge – page 76 top; page 77 top; page 78 top; page 79 top; page 80 top; page 81 top; page 82 top; page 83 top; page 84 top; page 85 top; page 86 bottom; page 87 top; page 88 top; page 89 top; page 89 bottom; page 90 top; page 91 top; page 92 top; page 92 bottom; page 93 top; page 94 top; page 94 bottom; page 95 top

First published 2013

Amberley Publishing
The Hill, Stroud
Gloucestershire, GL5 4EP

www.amberley-books.com

Copyright © Anthony Poulton-Smith, 2013

The right of Anthony Poulton-Smith to be identified as the Author of this work has been asserted in accordance with the Copyrights, Designs and Patents Act 1988.

ISBN 978 1 4456 0953 9

British Library Cataloguing in Publication Data.
A catalogue record for this book is available from the British Library.

Typeset in 9.5pt on 12pt Celeste.
Typesetting by Amberley Publishing.
Printed in the UK.

Introduction

Staffordshire's county town was founded around AD 700. The Saxon Bertelin of the kingdom of Mercia established a hermitage, and the outline of its chapel can be seen marked out by stones adjacent to St Mary's church. This shows the location of the original settlement on the bank of land surrounded by marshland and the rivers.

In 913, with the threat of attack by the Danes, Æthelflæd, Lady of Mercia and daughter of King Alfred the Great, and her husband Æthelred fortified Stafford as one of a chain of *burhs* across the Midlands. Industry came to the area in the shape of pottery, produced in the Roman style and known as Stafford Ware. Following peace with the Danes, the Normans arrived and, once again, the town was under attack. This time Edwin, Earl of Mercia, led the rebellion against the forces of William the Conqueror. This rebellion was not simply squashed but saw the town almost destroyed, and it was more than a century before it even began to recover.

It was the redevelopment of the early thirteenth century which created the basic layout of the town centre as we know it today. Further setbacks came in the shape of the Black Death in the thirteenth and fourteenth centuries and later the English Civil War in the sixteenth century. Continued early problems saw the importance of Tamworth to the south and the towns of the Potteries in the north exceed that of Stafford, despite its position as the shire town.

It was not until the coming of the railways in 1837, connecting the town with Birmingham and London to the south, and Liverpool and Manchester in the north, that Stafford began to attract industry and reflect its stature as the county town. Aside from the work brought by the railways, several lines met here to form an important junction, and at the same time Stafford became known for the production of boots and shoes.

The improved transport routes also enabled the town to attain something of the administrative importance associated with other county towns. Possibly the most imposing building from the nineteenth century was the original Stafford Gaol, which added to the earlier churches of St Chad's and St Mary's, and other buildings such as the Ancient High House, Stafford Castle, the Guildhall, the Swan Hotel, and the court buildings. From 1903 the name of Stafford has

been synonymous with heavy electrical engineering. The production of power station transformers at the works brought names such as Siemens, English Electric and GEC, while Perkins Engines and Bostik still have their factories here.

Since the 1960s the borough has undergone many changes. Hardly a year seems to pass without some building springing up or a road being laid or closed off for pedestrians. Undoubtedly the biggest change in the town centre has come in the shape of the ring road; many buildings were cleared to ensure the traffic followed the busy A34 around the town centre and not through it. The Beeching closure of the rail links to Uttoxeter and Shrewsbury did reduce the importance of Stafford as a junction; however, this was offset by the opening of the M6 motorway, with junctions both north and south of the town.

Within these pages we shall look at the changes over the last century or so. Not only in terms of the town but also the people and the places where they lived, worked and even shopped. The fascinating images, old and new, enable the reader to share the changes, and it may come as a surprise to find out what has changed and what is still very much recognisable a century later.

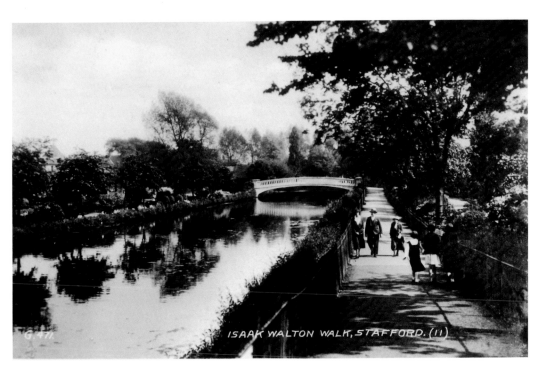

Isaak Walton Walk

Isaak Walton Walk, thought to be during the 1920s. The author of *The Compleat Angler* must have taken this walk himself on many occasions, and today the path is trodden more often than ever both by residents and visitors.

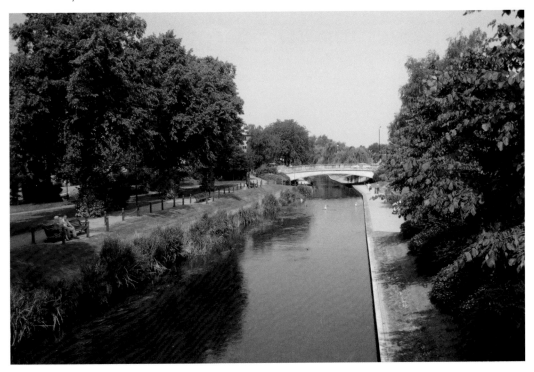

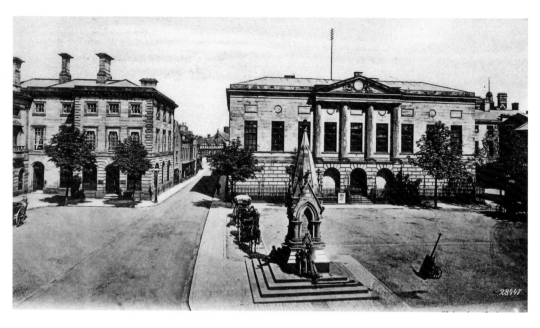

Market Place

Little change has taken place since the Victorian era for Market Place. Both buildings, including the Shire Hall, are still very recognisable and only the square itself has really changed.

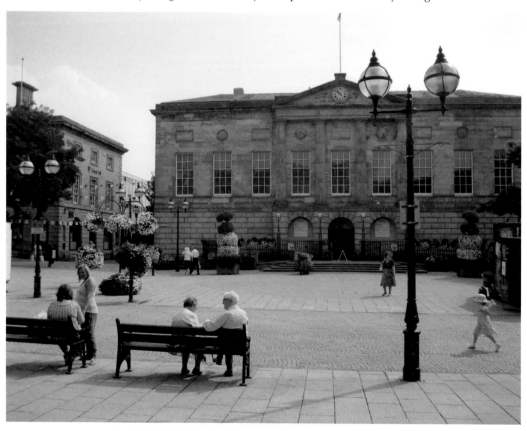

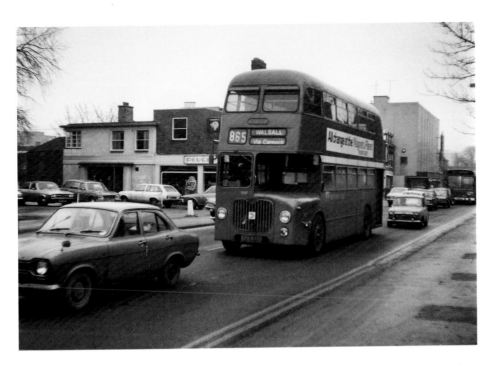

Midland Red
A D9 Model in 1976 when Midland Red vehicles, like this example heading towards the railway station, were rarely seen in their original poppy-red colour, being more usually covered in the grime thrown up from the road. Modern buses might be sleeker, more comfortable, and much quieter, yet the sound of the diesel engine turning over or revving away from the stop will surely evoke more memories than the hiss of the hydraulics of the modern buses ever could.

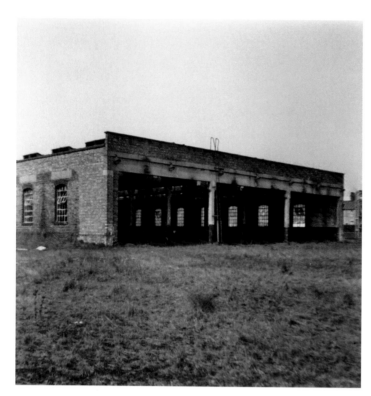

Locomotive Sheds
Stafford locomotive sheds pictured in 1974. Today the only sign of the old siding leading here are the footpath and cycle path which run along the same line, while the shed area to the left is completely overgrown.

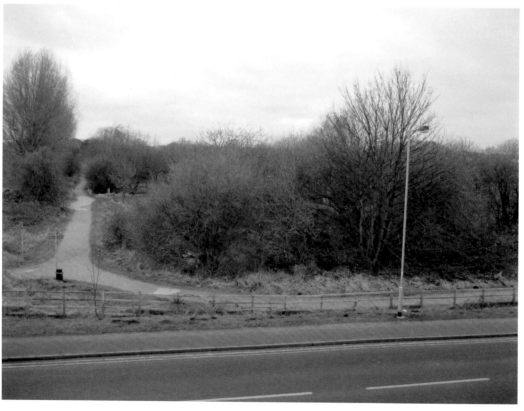

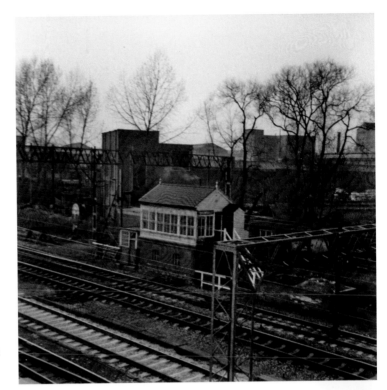

Signal Box
Queensville signal box, just south of Stafford, in 1974, compared with a view from the station platform in the twenty-first century.

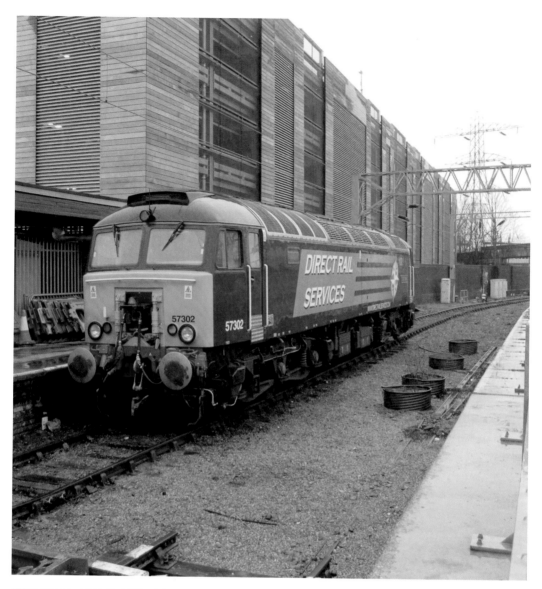

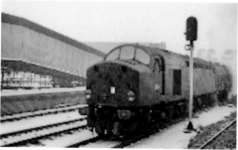

Winter Troubles

A picture from 3 January 1962 (*left*); the cold weather has put paid to the steam-heating boiler on the diesel, hence the steam engine behind provided heating for the train. No such problems fifty-one years later for the diesel in the siding at Stafford station, when the weather was not as cold but extremely damp.

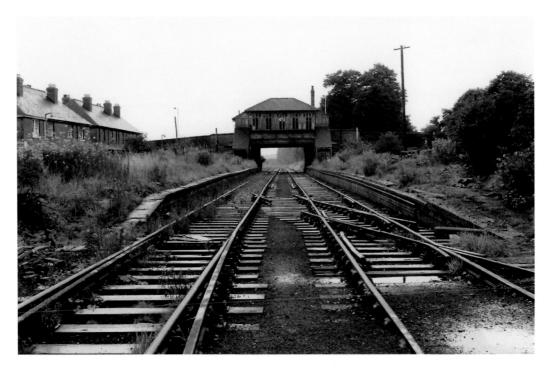

Stafford Common Station

Stafford Common station in August 1968, with a modern view looking the opposite way. The edges of the platform are still evident, while behind the camera the road bridge is still in use but the station building has gone along with the train service.

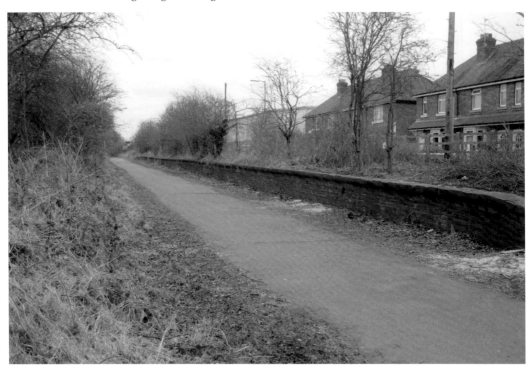

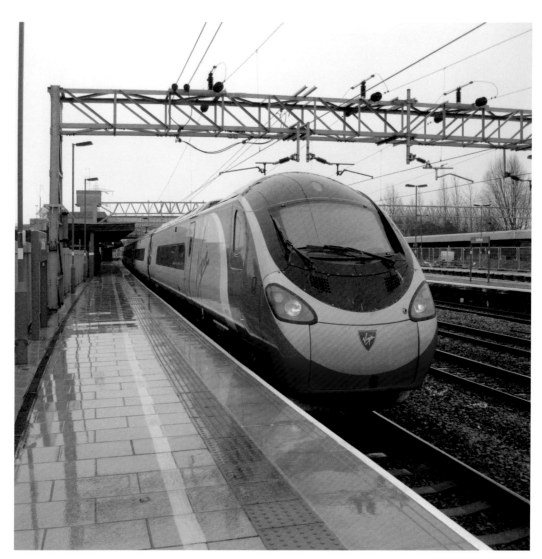

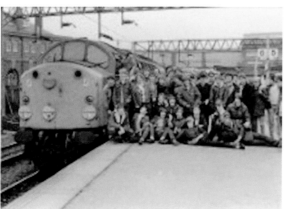

Diesel Enthusiasts
Diesel engine 40 044 pauses at Stafford in March 1984 on its journey to Birmingham New Street from Manchester Piccadilly, allowing a group of '40' enthusiasts to gather for the camera – several in some strange poses! Above, a sleek, modern electric train is just pulling out of Stafford on a wet Sunday morning in 2013.

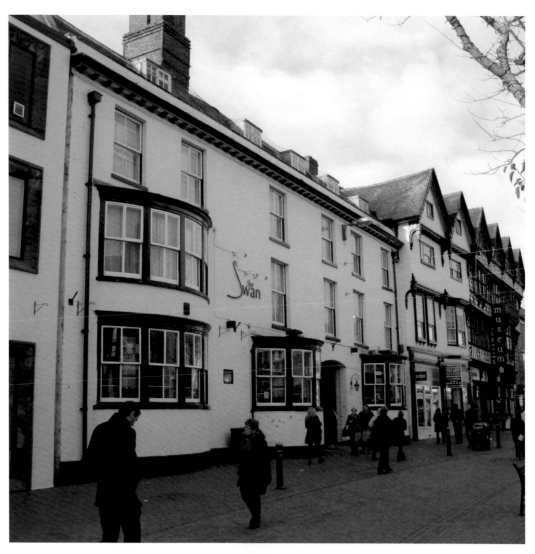

Swan Hotel

The Swan Hotel seen in a busy High Street in the first half of the twentieth century. Today the street is pedestrianised and yet, because of delivery vehicles, ironically there is probably more traffic today when vehicles are banned than there were on this road almost a century ago.

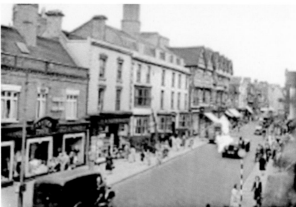

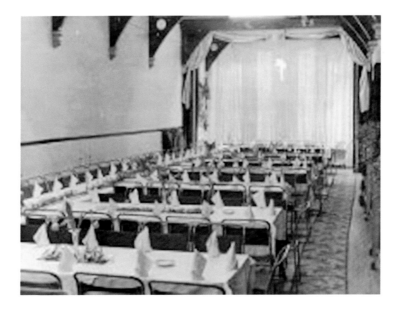

Swan Hotel

The hotel is thought to have originated as two houses joined together by an arch to form the courtyard of the early coaching inn. From the rear it is easier to see how the smaller buildings became connected.

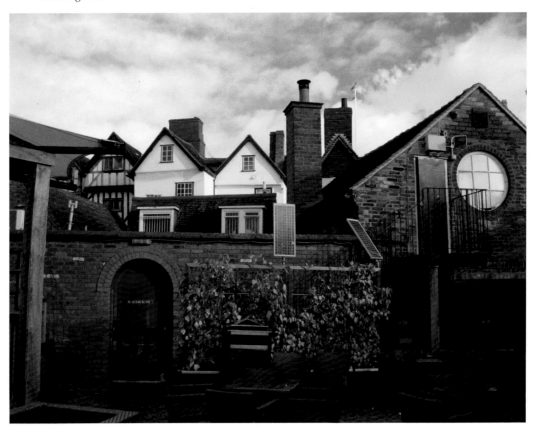

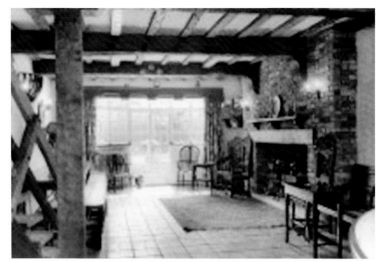

Swan Hotel
Seating on the patio at the Swan Hotel as seen in the 1930s, and again twenty-first-century style. Here, during warmer months, not only drinks but live music can be enjoyed.

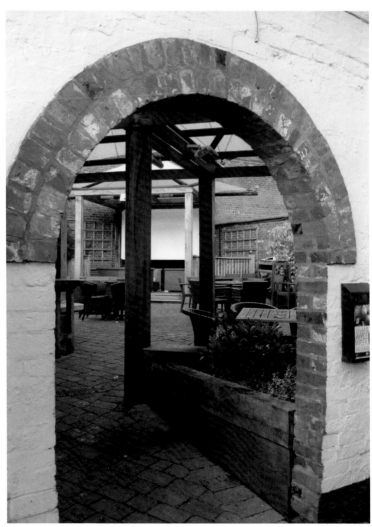

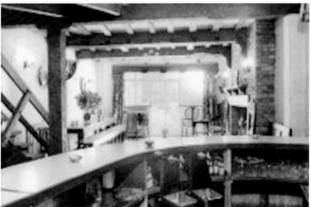

Swan Hotel
Another view of seating; this was originally the passage through to a stable at the rear, but continues to offer hospitality today.

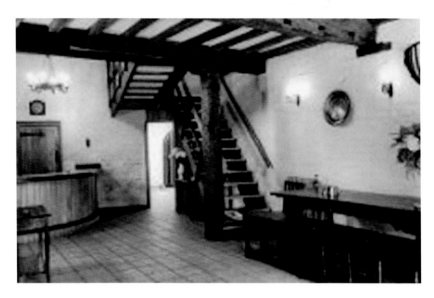

Swan Hotel
The view from behind the bar and, below, the entrance for the coaches, which would allow passengers to alight in the dry no matter what the weather.

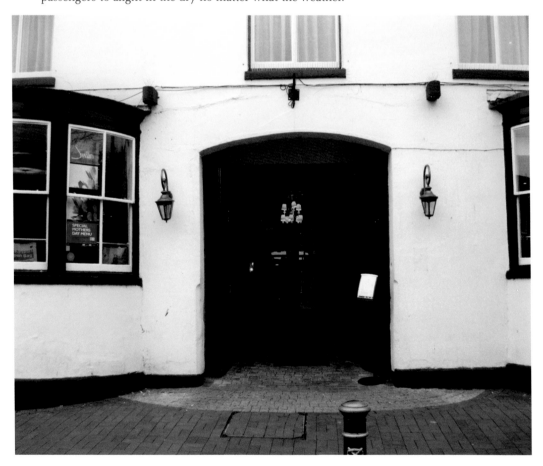

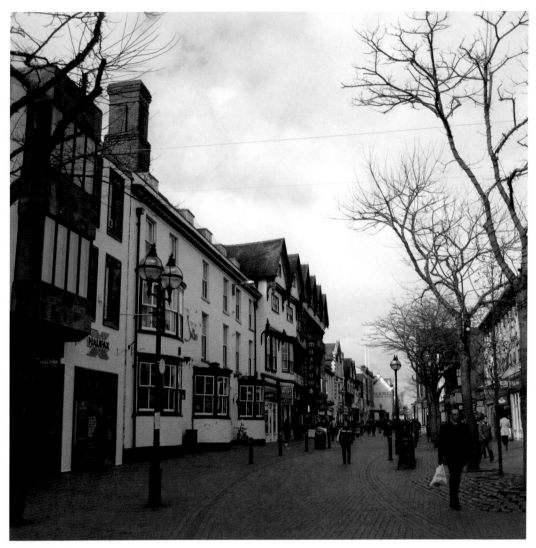

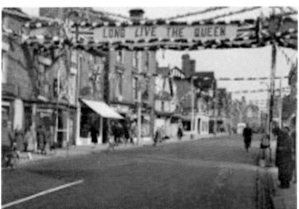

Swan Hotel
Looking down Greengate Street, which today is as busy as ever. In the early image the occasion is clear, with the message 'Long Live the Queen' showing this was the coronation of Queen Elizabeth II in June 1953.

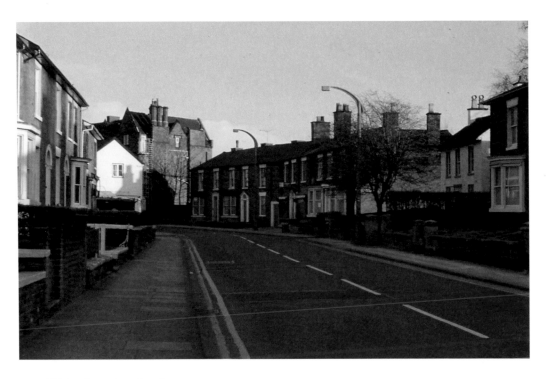

Wolverhampton Road

The A449 Wolverhampton Road looking north to the junction with White Lion Street, the first of a number taken in 1976 before the ring road changed the face of Stafford forever and, as the second image shows by the disappearance of the large buildings at the end of the road, shortened the A449 by a few yards.

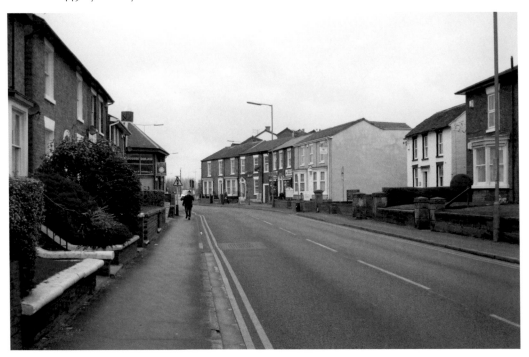

Drakeford Court
Wolverhampton Road and White Lion Street, where the former annexe to Stafford College of Art and Timmis Antiques have made way for Drakeford Court.

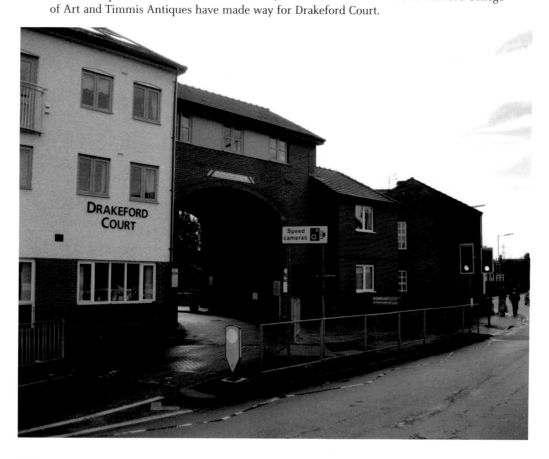

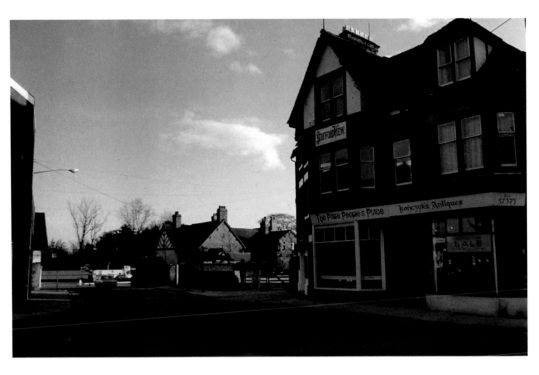

White Lion Street

Looking down White Lion Street, which is now a cul-de-sac leading to nought but a car park. Hardly any buildings remain from the earlier White Lion Street.

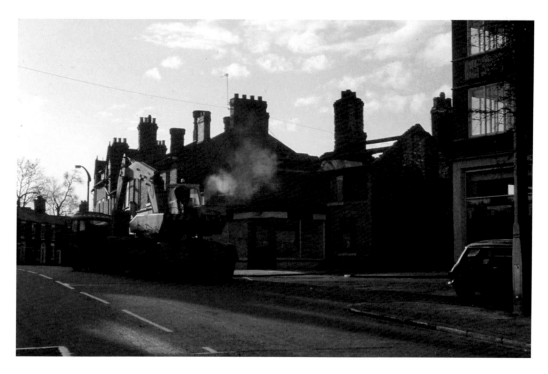

The Green or Friary Retail Park
The demolition team are already hard at work at Davies Fruiterer's and Burgess Agriculture. Neither building needed to be removed as part of the new ring road plans; their end had already been planned before the ring road was mooted.

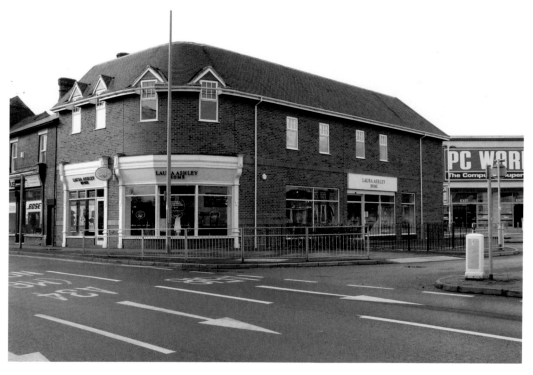

The Town Lock-Up

The White Lion pub with, on the right, the lock-up, was said to be where drunks were once held overnight. This tiny building was built in the late eighteenth century and, following the demolition of the adjoining pub in the 1970s, was restored in 1980.

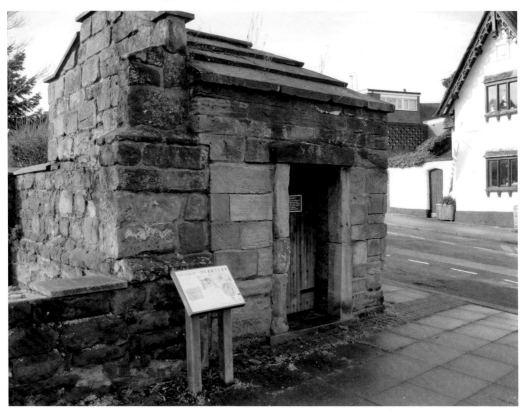

White Lion Street
Looking straight along White Lion Street to Wolverhampton Street. What was once a much used thoroughfare, White Lion Street is today simply a car park.

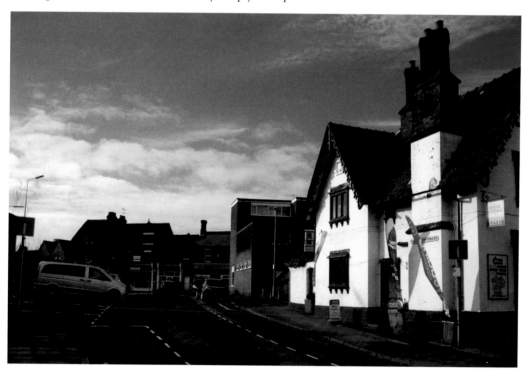

Green Hall
Looking along Lichfield Road towards Green Hall, the oddly named white building served as the offices for the county council until quite recently.

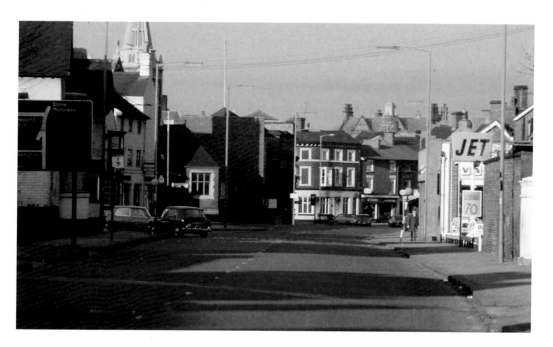

Lichfield Road

The lens in the upper image distorts the distances involved, bringing central images nearer the camera, while making those on the periphery impossible to reproduce in the modern era. For comparison, judge the distance between the surviving church on the left and the Grapes public house in the centre.

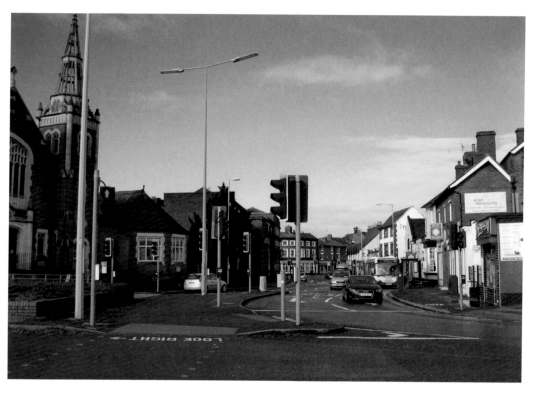

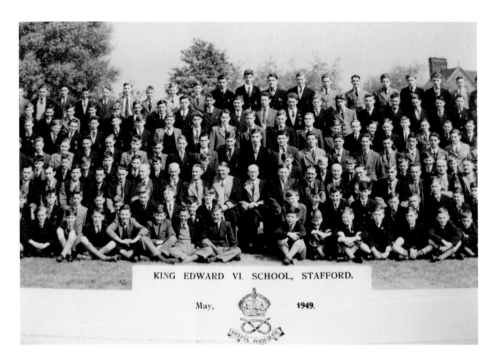

KING EDWARD VI. SCHOOL, STAFFORD.

May, 1949.

D. J. D. Smith

Headmaster of King Edward VI Grammar School from 1949, D. J. D. Smith is remembered for many reasons – some have fond memories, while others recall a fearsome character. But all would recognise the man seated in the centre in the classical gown worn by schoolteachers. Below is a view of the school from Friar's Road.

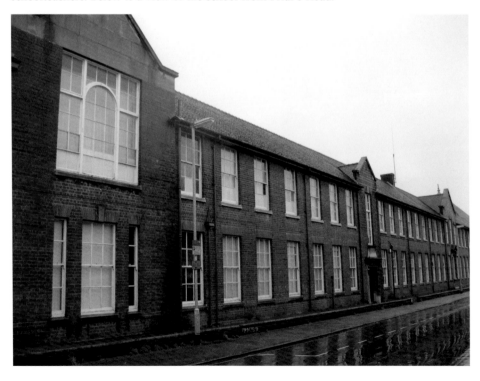

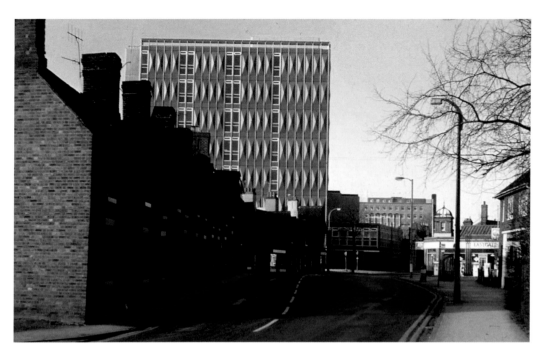

Eastgate Street
Along Lammascote Road into Eastgate Street, the large building dominating the picture is the former telephone exchange.

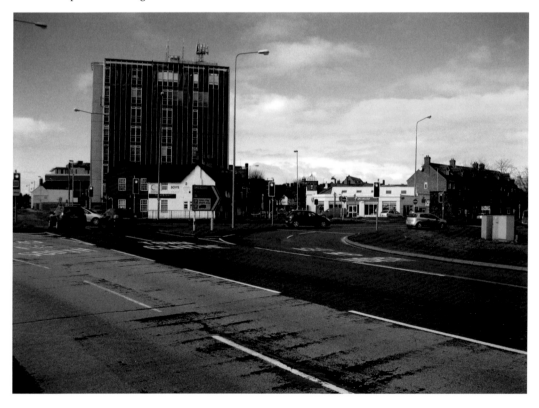

Lammascote Road

Looking along Lammascote Road in the opposite direction reveals that much of what we see, including the Unicorn Hotel, was demolished as part of the development.

Stafford Town Wall
The remnant of Stafford's town wall stands edge-on beyond the petrol station. In the centre is a building affectionately known as the 'Tin Cow' by locals, as it had a machine dispensing cartons of milk outside it.

Pitcher Bank
Eastgate Street where, on the right, the area known as Pitcher Bank boasted a Chinese laundry and a pet shop.

Shrewsbury Arms

Another view of Pitcher Bank. Beyond the bus stands the Shrewsbury Arms on the right and the old joinery works to its left. Some buses still stop along here, with Midland Red being replaced by Arriva Blue.

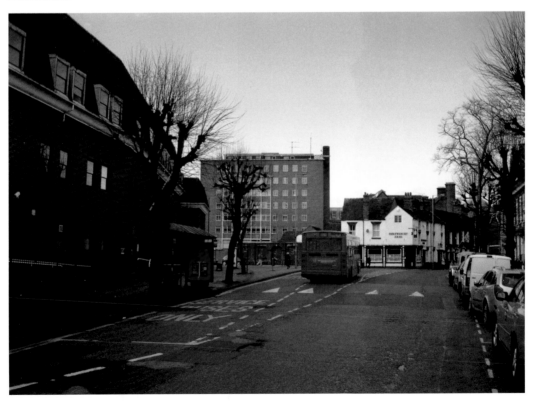

Gaol Square

Gaol Square after an earlier road improvement scheme in the 1960s. The traffic was brought here through Gaolgate Street, Gaol Road, Chell Road, and North Walls before the present-day ring road was started the following decade.

Foregate Street
Looking along Foregate Street with a row of shops on the left and Staffordshire General Infirmary opposite. The pile of bricks on the right used to be the garage of Charles Clarke & Son.

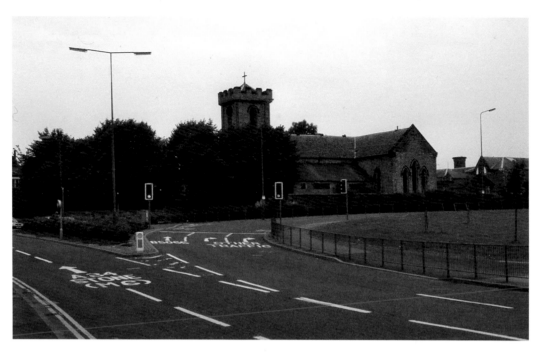

Christ Church
Looking north-east along Foregate Street, with Christ Church dominating the view. Today Christ Church has gone and we see the sheltered accommodation known as Churchill Homes.

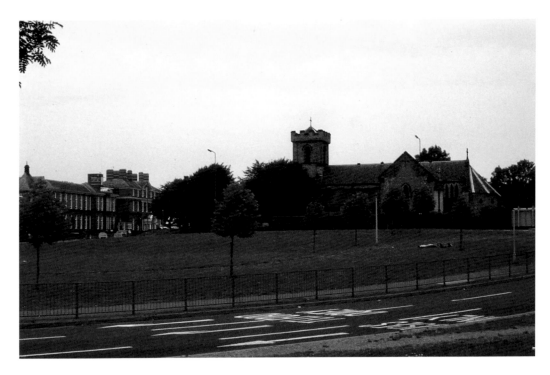

Christ Church and the Infirmary
Christ Church with a view looking from the opposite side with the Infirmary to the left. There is no sign of deforestation in these images!

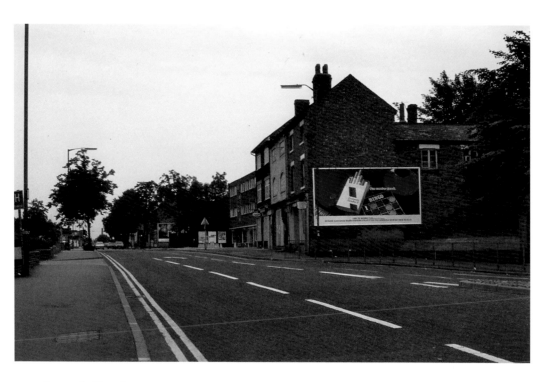

Foregate Street

This time we see Foregate Street from beyond where Christ Church stands, and a similar view in 2013. Note that the road has been widened significantly.

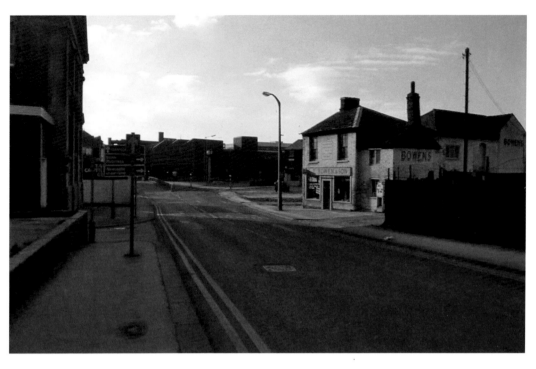

Gaol Road to Gaol Square

Looking from Gaol Road toward Gaol Square. Bowens, which supplied many gardeners over the years with everything from tools to plants, is seen on the right of the above image.

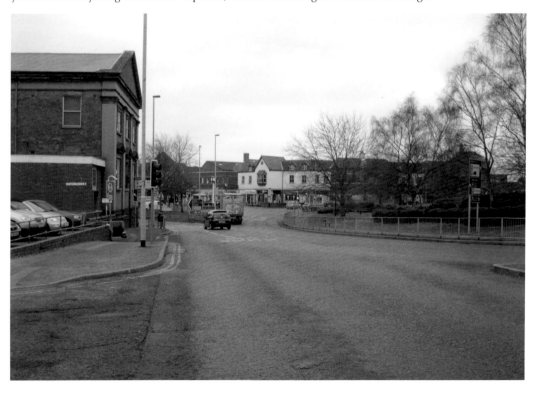

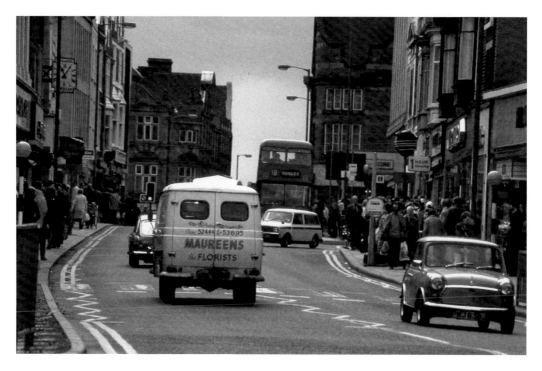

Gaolgate Street

A view from Gaol Square along Gaolgate Street to Market Square. When the early image was taken this was still a section of the A34, one of the major trunk roads in the country, and was not pedestrianised.

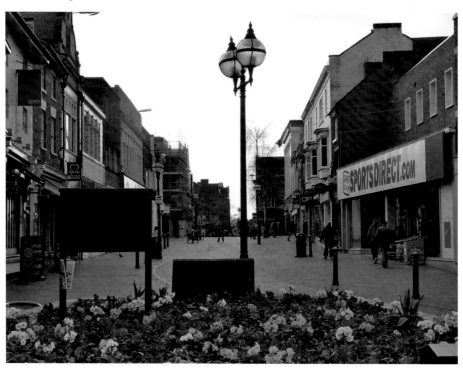

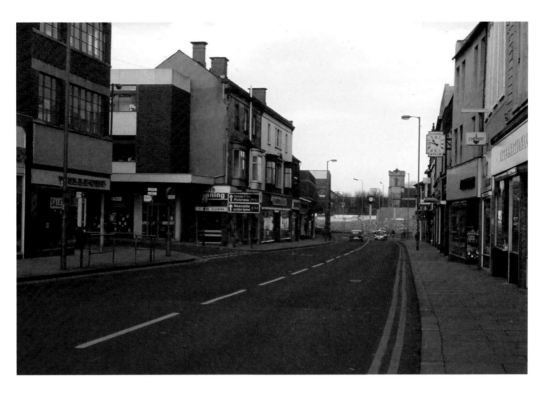

Gaolgate Street North

Looking the opposite way along Gaolgate Street, with the tower of Christ Church visible in the distance. Gaolgate Street is now pedestrianised.

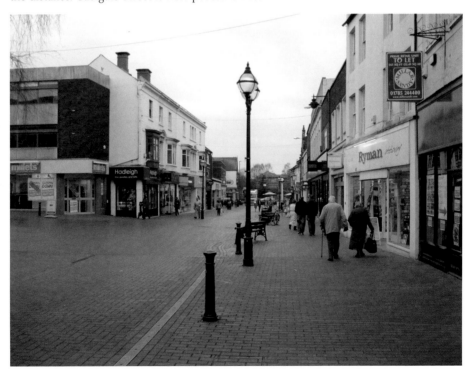

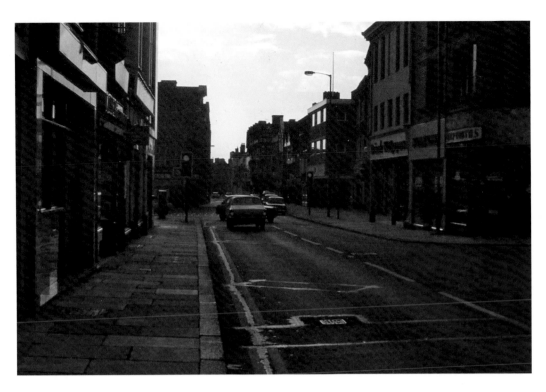

Gaolgate Street South
Looking south along Gaolgate Street from the junction with Crabbery Street towards Market Square. Many of the businesses have changed in the years between these two photographs.

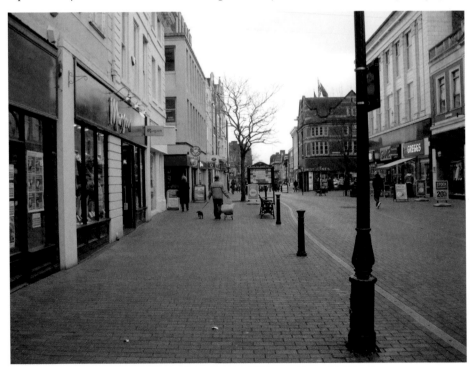

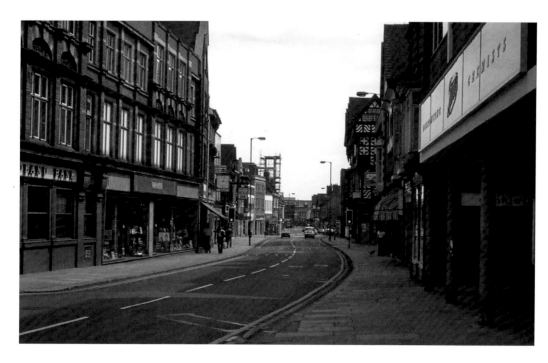

Greengate Street
A view along Greengate Street into Bridge Street and as far as Stafford Library in the distance.
The easily recognised Ancient High House is on the right, with (*inset*) the former Stafford Library
building in the far distance.

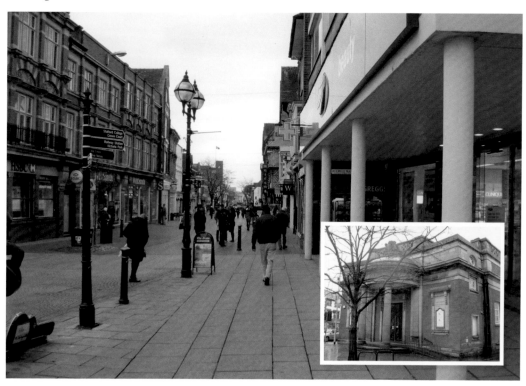

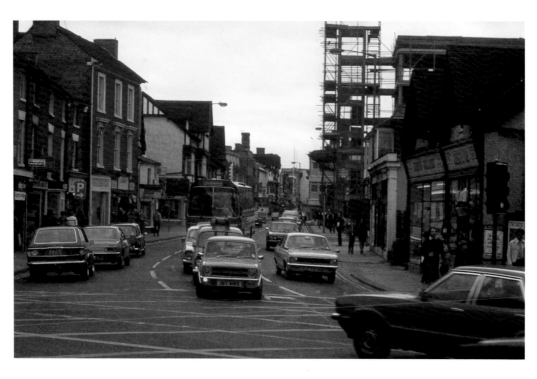

Greengate Street

Looking the opposite way, this image was taken on the steps of the old library with the scaffolding marking the position of clock tower outside Stafford Borough Council's offices.

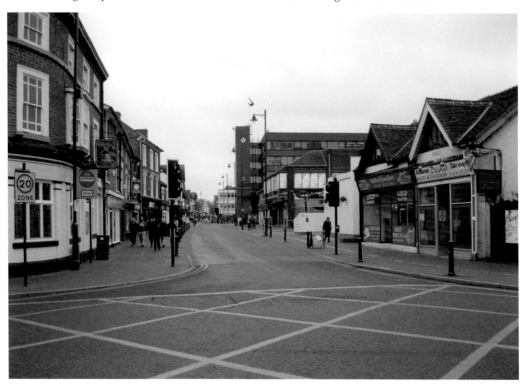

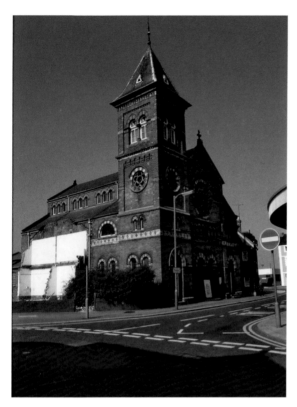

Guildhall Shopping Centre
The tower of the former Wesleyan Methodist chapel was retained for the new Guildhall shopping centre. Broad Street can be seen in the background.

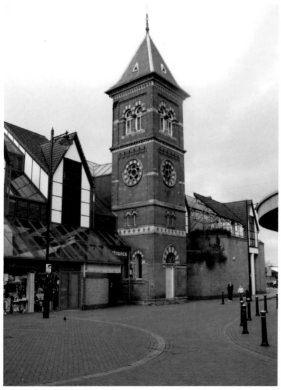

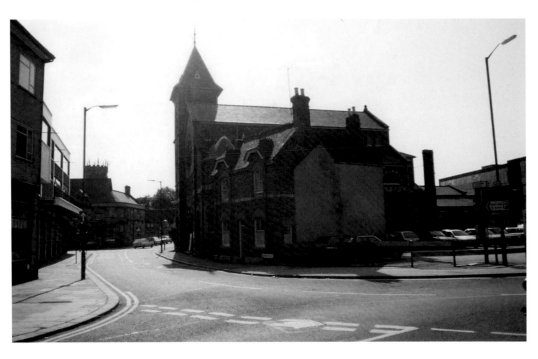

Chapel Street
The reverse view along Chapel Street, and again the tower is visible. The remainder was removed and replaced by the new multistorey car park.

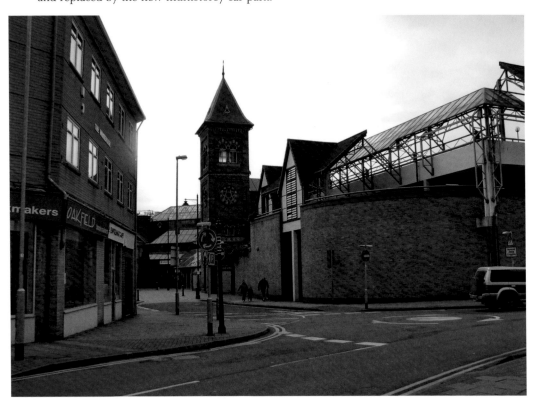

Bath Street

The old police station in Bath Street in the process of being demolished in the photograph above. The second view is taken from exactly the same spot in the new Guildhall shopping centre.

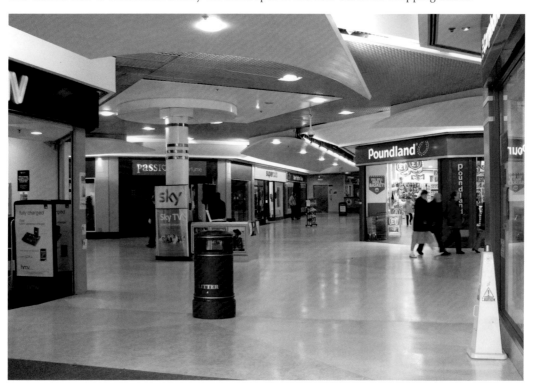

Stafford Market Entrance

The old entrance to Stafford Market and the same view today, again in the Guildhall shopping centre. Without local knowledge this view could never seem to be related.

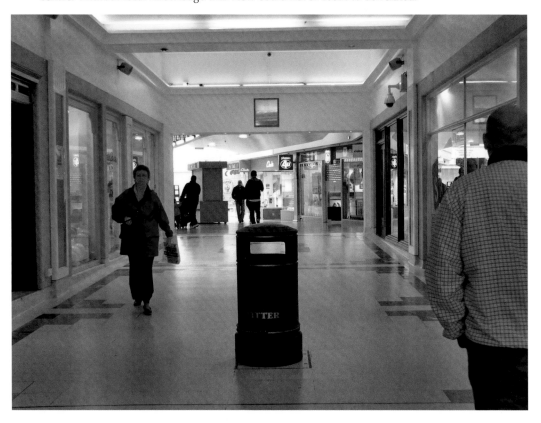

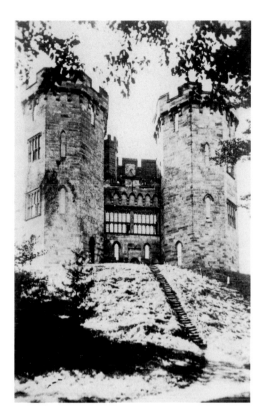

Stafford Castle
The castle was built and rebuilt several times. The old image shows how it looked when it was an example of Gothic Revival architecture and ostensibly a house. As can be seen, the modern building is much lower, having been dismantled to prevent it from collapsing.

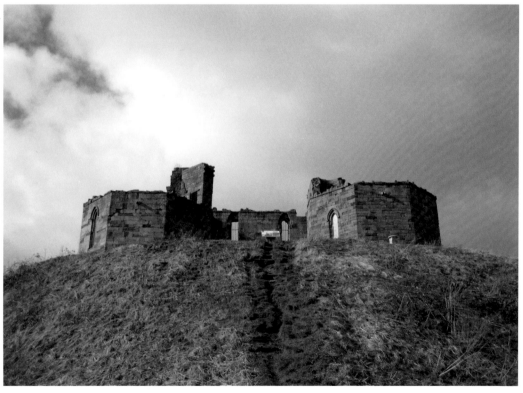

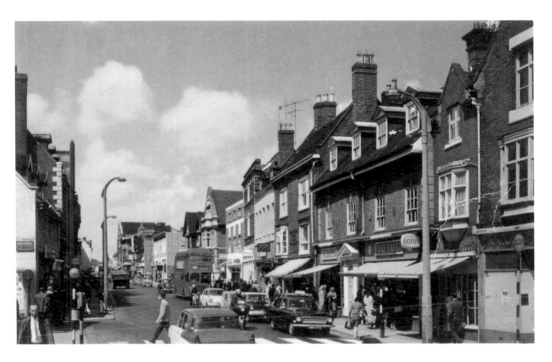

Greengate Street

Looking south along Greengate Street, with Mill Street on the left and on the right. A name associated with Stafford for many years, Lotus Ltd, shoemakers, can be seen on the right of the old photograph above.

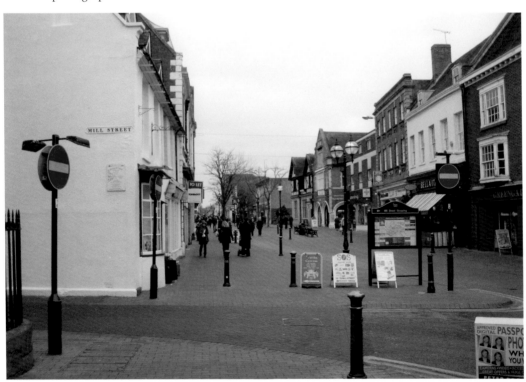

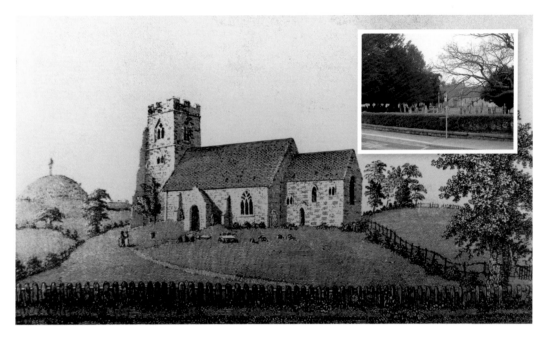

Castle Church

Castle church, pictured above in the eighteenth century, is dedicated to St Mary. If the early image is to be trusted it is clear the number of trees today vastly outnumbers those of yesteryear, although the wood beyond is hidden by the trees in the foreground.

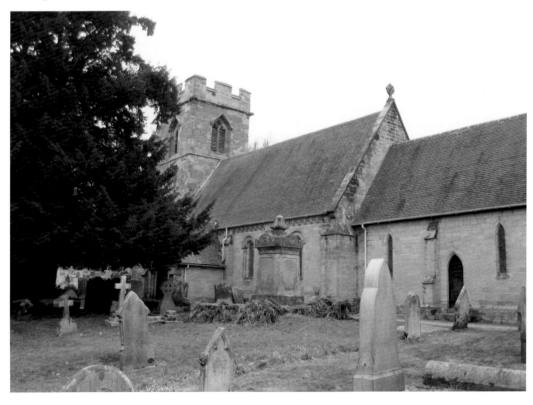

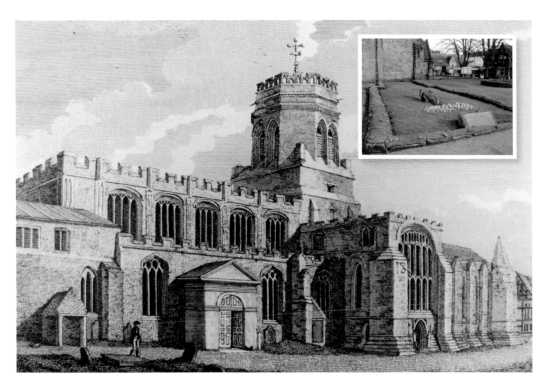

St Mary's Church
St Mary's church in Stafford has seen little change over the centuries. Yet religion goes back much further on this site for, seen below, the outline of the earlier chapel, dating from more than a thousand years ago, was alongside the present church.

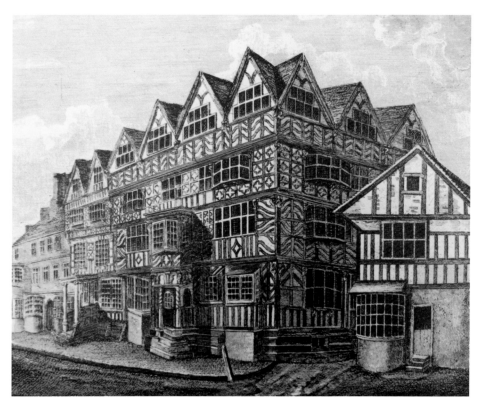

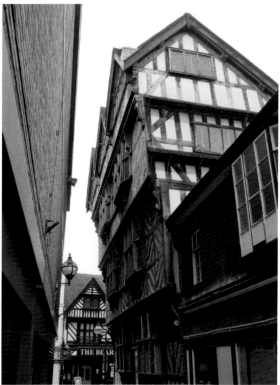

Ancient High House

The Ancient High House was simply known as the High House in the late eighteenth century, and can boast of being the largest surviving timber-framed building in the country. Even when it was built it was quite an undertaking, as evidenced by the seven years it took to construct. The new image shows how the upper storeys overhang the lower floors.

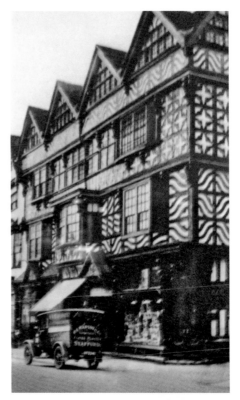

Marson's Grocery Store

A classic delivery van is seen passing the Ancient High House. Today the building is a museum, and on the first floor we see an impression of the high-class grocery store of William Albert Marson, who inherited this property in 1876. Note that Marson's shop was on the ground floor when it was open for business.

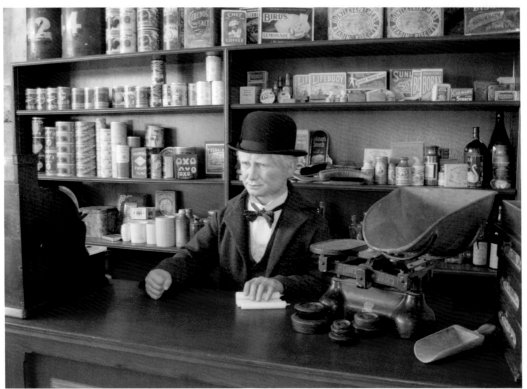

Oxford Street
Two views along the same road. It was known as Oxford Street in the period between the wars (*above*), and is known as Oxford Gardens in 2013 (*below*).

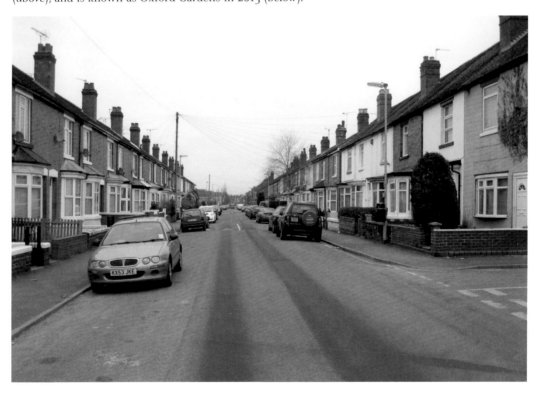

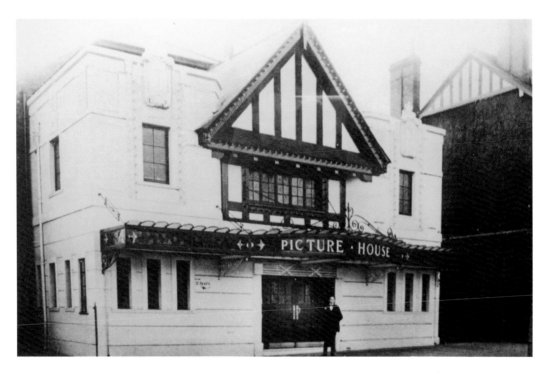

Picture House
A superb image of the cinema, once officially known as the Picture House, and indeed it still is, although today it serves up ales and meals instead of popcorn and reels.

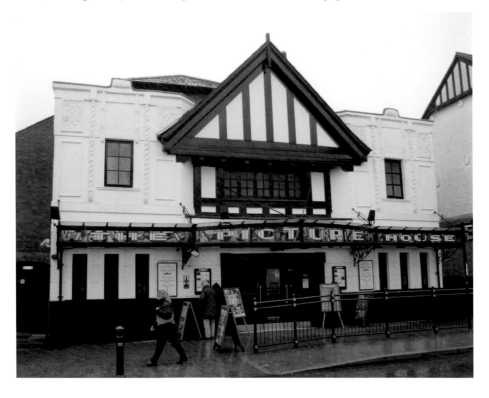

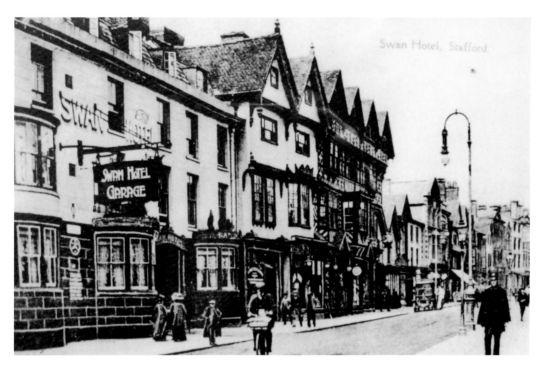

Swan Hotel

Swan Hotel and Ancient High House are pictured here, possibly during the late 1920s. Note how the sign advertises the Swan Hotel Garage, showing that cars were welcome through the arch built for the days of the coaching inns.

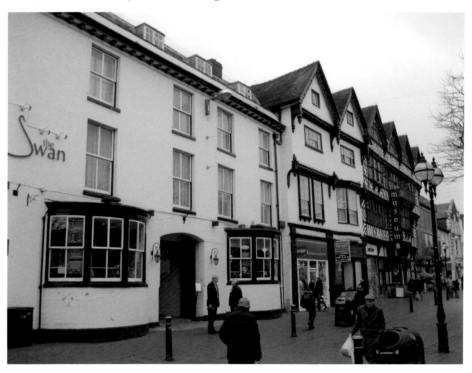

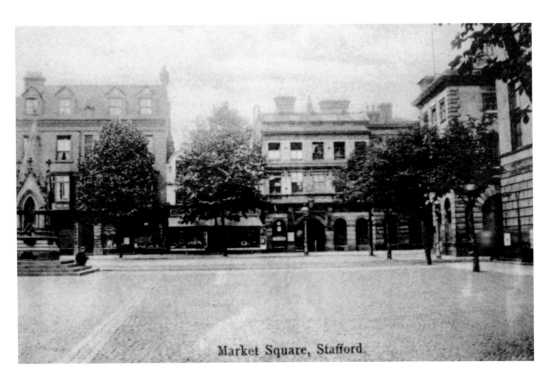

Market Square, Stafford.

Market Square
A delightful view of Market Square, where architecturally so little has changed it would be easily recognised by Staffordians from any era.

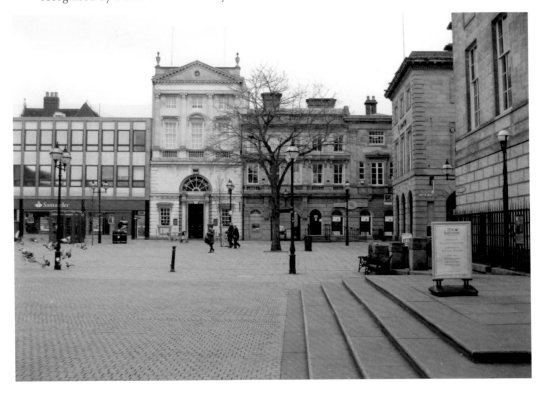

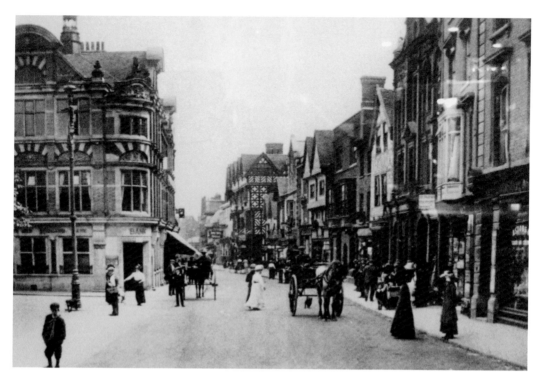

Greengate Street
Looking along Greengate Street from Market Square in the early days of the twentieth century. Pedestrianisation today means horses would still be allowed, and they were a common sight a century ago.

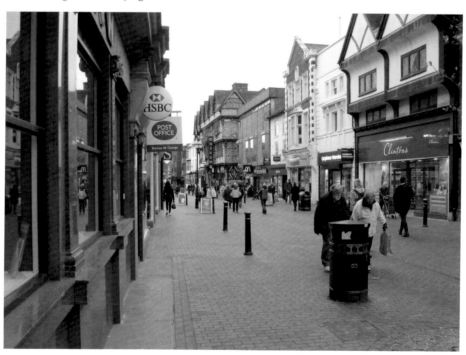

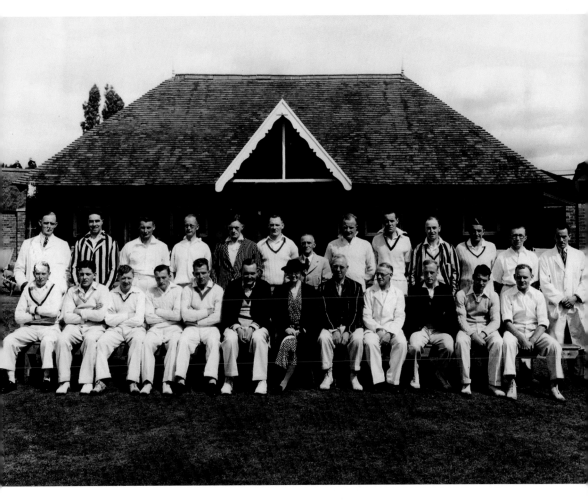

Stafford Cricketers

Seen here, a contrast between the whites of the cricketers of 1943 and the coloured kit of the modern era. The woman featured in the older image is unknown, although it is assumed she was probably there to represent her husband in some capacity.

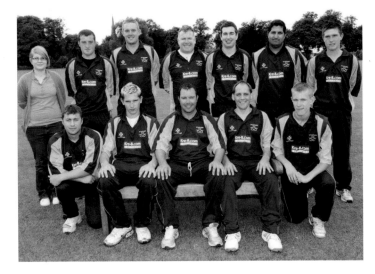

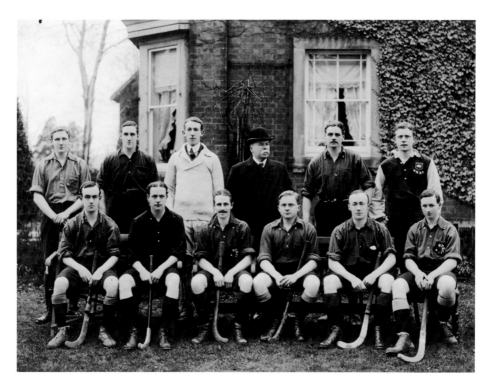

Stafford Hockey & Cricketing Greats

The hockey team of 1923 is seen in the top photograph, while below is the modern version. Note the differences in attire as well as equipment.

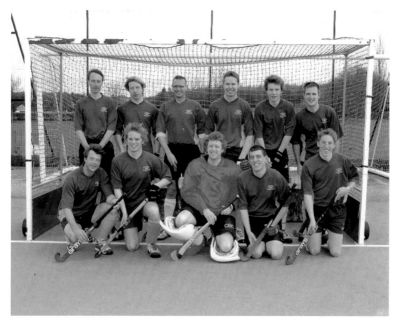

The Cricket Ground

In 1954 a gathering of Staffordshire's cricket's finest (*right*) including, on the far right, S. F. Barnes. Syd Barnes was one of the best fast bowlers ever to represent England. Although he only played twenty-seven tests, remember that test-playing nations numbered just three at the time; he took 189 wickets at an average of under 17. Doubtless he troubled the scorers at the ground, seen above in winter.

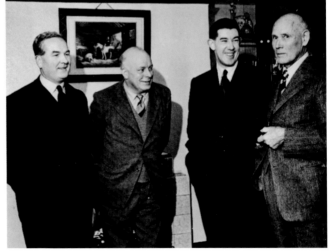

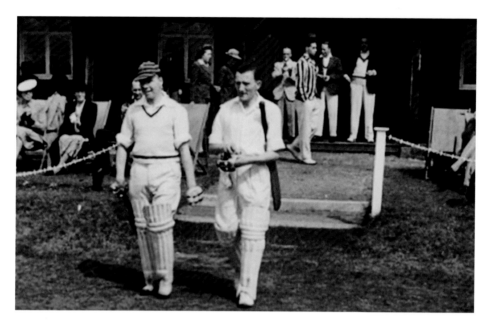

Cricket
The openers emerge from the pavilion in 1943. Below an image of the ground seventy years later.

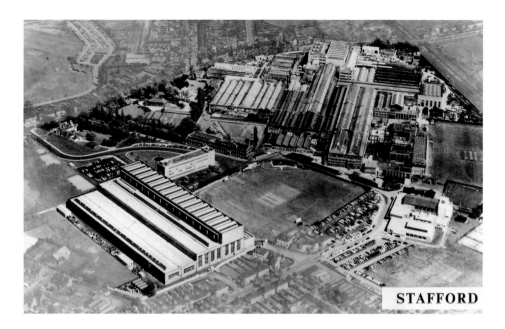

STAFFORD

General Electric
The Hough cricket ground is seen here from the air in the 1960s. The General Electric Company's works is alongside, where heavy electrical engineering continues to provide employment today.

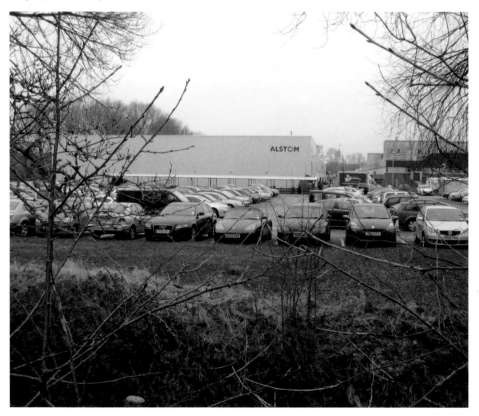

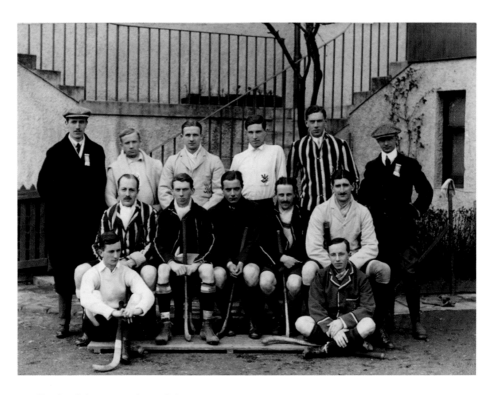

Stafford Cricket & Hockey Club
An image from the scrapbook of W. H. Twigg, thought to have been taken around 1912, although the location is unknown. Today the cricket and hockey clubs work side by side.

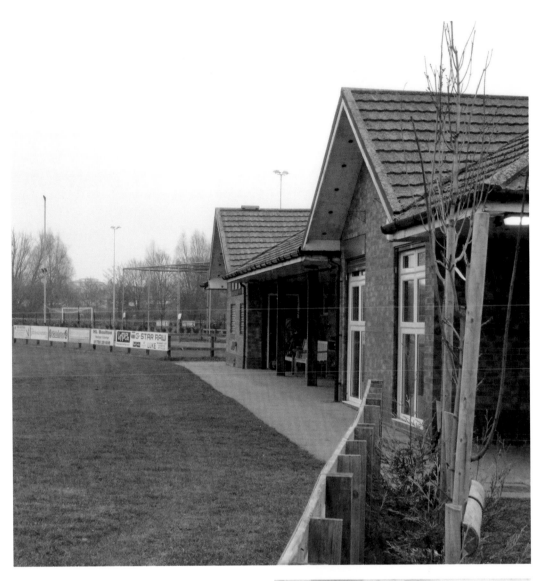

The Pavillion

Another from the W. H. Twigg scrapbook: the Twigg family is pictured right, although the date and location were not recorded. Doubtless the modern pavilion in the main picture is a more substantial and luxurious building than Mr Twigg could ever have imagined.

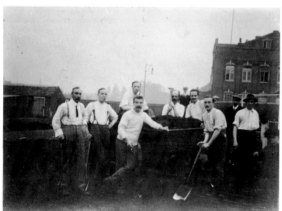

Groundsmen
Men working on the Hough in a picture probably taken in 1907. Today the groundsmen will be responsible for adjusting sightscreens and ensuring the square is adequately covered during more inclement spells of British weather.

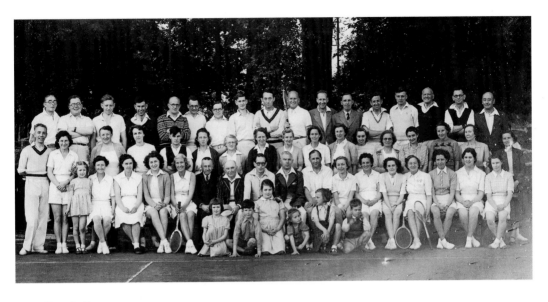

Tennis Courts

The tennis-playing arm of Stafford Cricket Club is pictured here in 1949. In the district of Doxey the tennis courts are about to be developed, while the former cricket ground is little more than a water meadow.

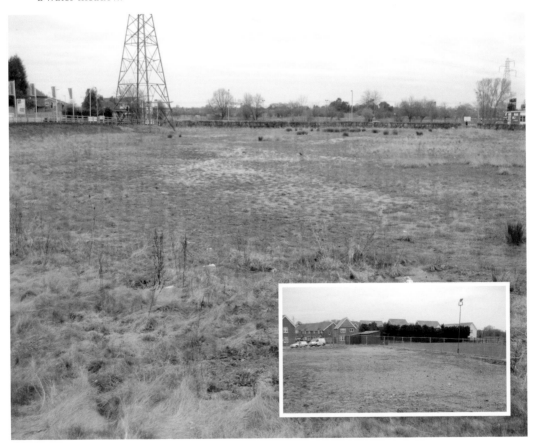

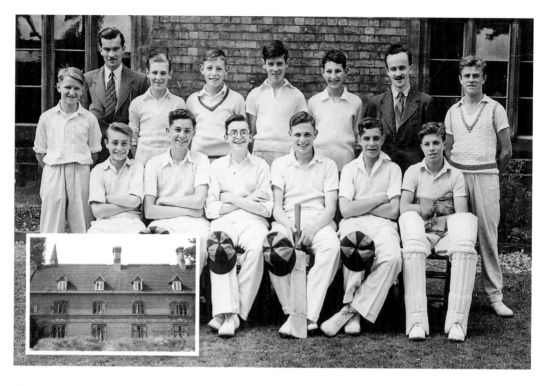

King Edward VI Grammar School
The boys were proud to represent their school, be it at rugby or cricket. Inset, a view of the Grammar School today.

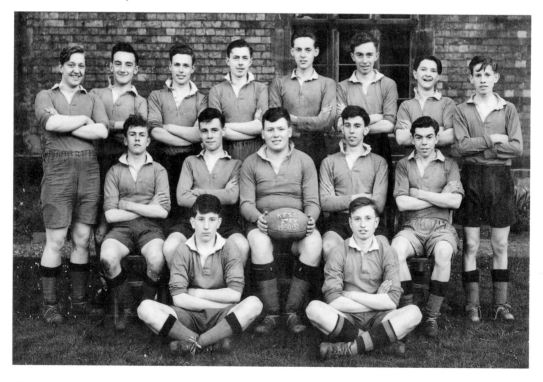

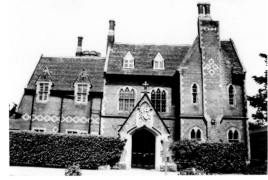

Stafford Grammar School
An early image of Stafford Grammar School, probably around the 1920s, and again almost a century later.

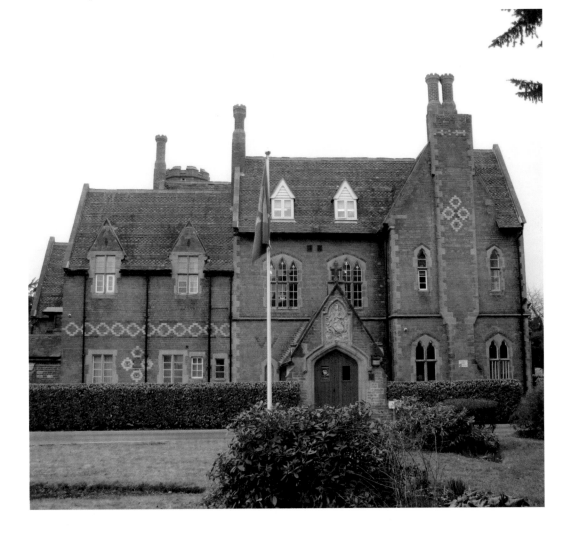

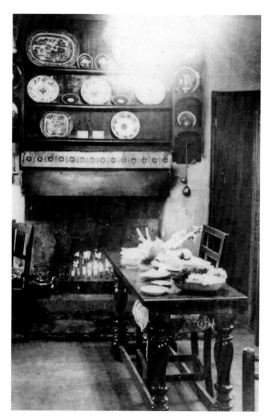
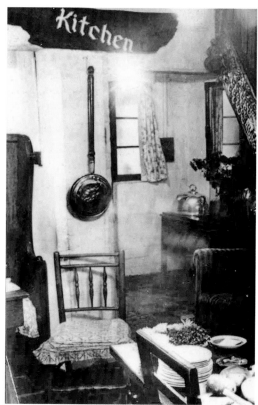

Soup Kitchen

This sixteenth-century building gets its name from the Victorian era, when the well-to-do purchased tickets for their meals, of which a portion would be allocated to the have-nots. Of course they never dined at the same time. The old images are from 1947 and show the kitchen and seating area.

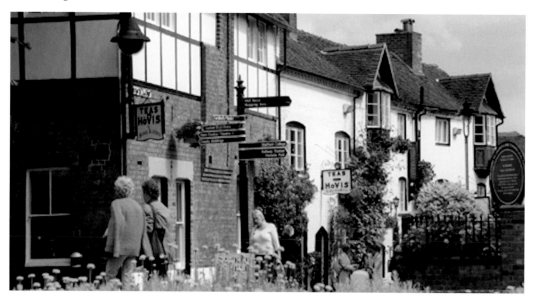

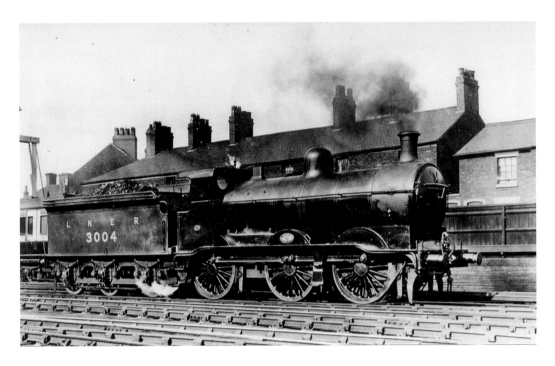

Stafford Railway Junction

While it has been almost obligatory to point fingers and ridicule trainspotters ever since the first locomotive ran along the Stockton & Darlington line, they have recorded an incredible amount of information over the years that can only be envied by others. Here the Great Northern Railway's class J21 0-6-0 No. 3004 is pictured at Stafford on 4 September 1926. While the lower bridge today crosses nothing, in the 3004's day a single-track line ran beneath the bridge.

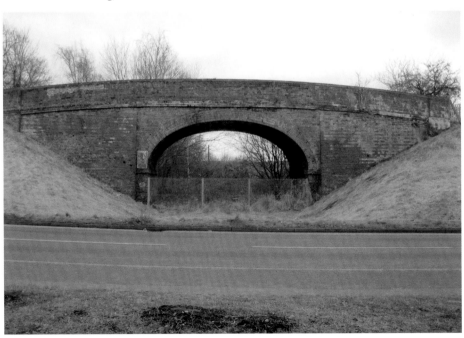

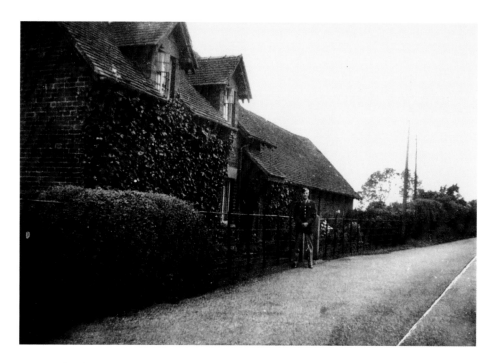

RAF Stafford

Captain Frank W. Kazmer relaxes on the outskirts of the town when he was stationed in Britain during the Second World War. As a commander of a combat engineer unit, Frank saw action at the Battle of the Bulge where he first destroyed the bridges and then helped to rebuild them as the Allies advanced. Coming to Britain in 1943, he fought in Europe until November 1945 when he returned to his home town of Hot Springs, South Dakota, via Massachusetts. One wonders what he would have made of the Harrier GR3's maximum speed of 737 mph and ceiling of 50,000 feet.

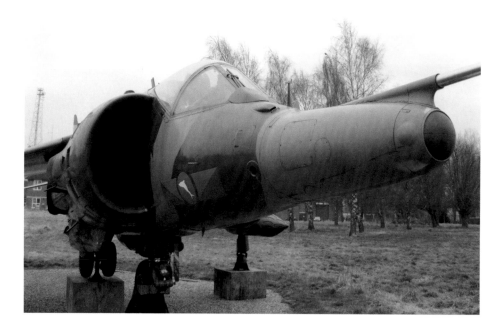

School Playing Fields
Above, a view across the grammar school playing fields. Today this is obscured by the large superstore and its car park.

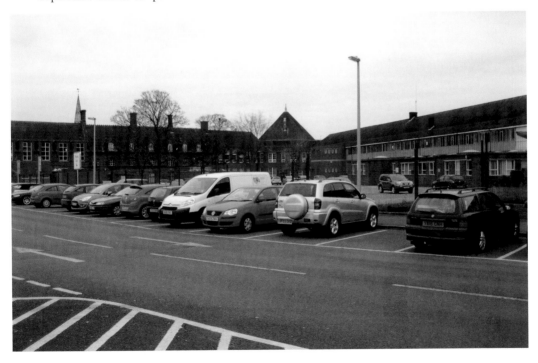

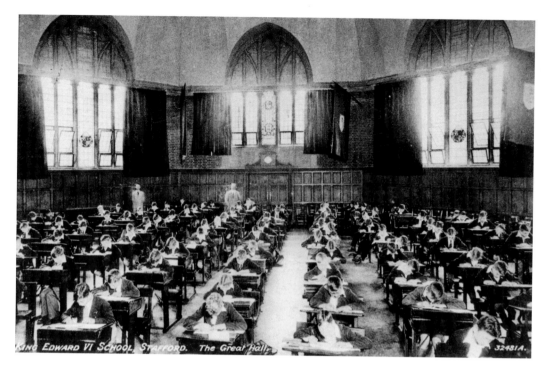

King Edward VI School, Stafford. The Great Hall.

The Octagon

At the King Edward VI Grammar School, the room known as the 'Octagon' made the perfect place to align rows of desks for the dreaded end-of-year exams. While the lower left image shows that vegetation once adorned the outer walls, this has now been cleared. Although removing the climbing plants certainly protects the structure, it is not as aesthetically pleasing.

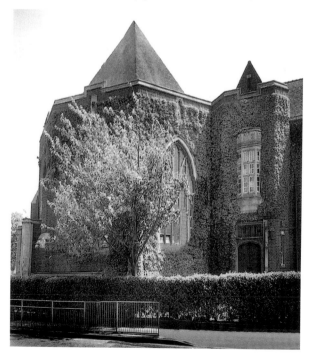

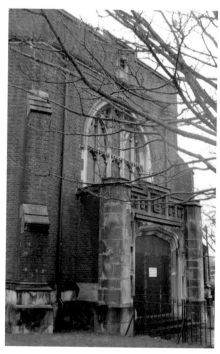

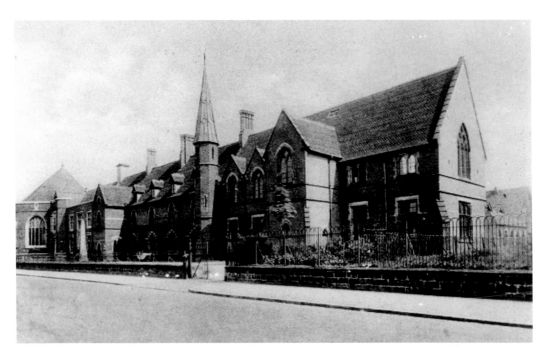

King Edward VI Grammar School
The frontage of King Edward VI Grammar School as seen from Newport Road. Today the view
is restricted by the hedge, although the building and the fence are identical.

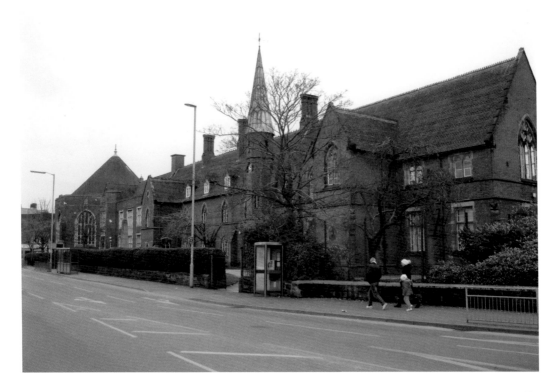

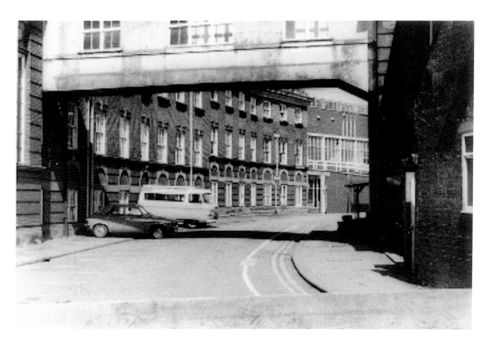

Cherry Street

Cherry Street has not just changed but has been completely eradicated by the new college buildings. The earlier photograph is thought to have been taken in the 1960s.

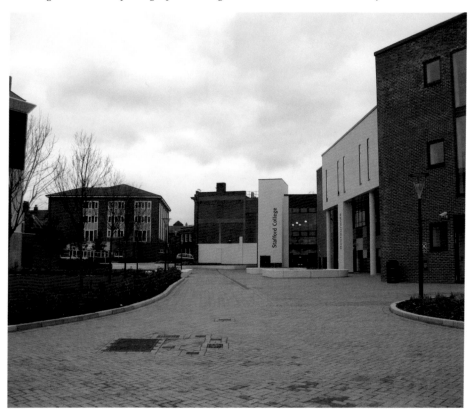

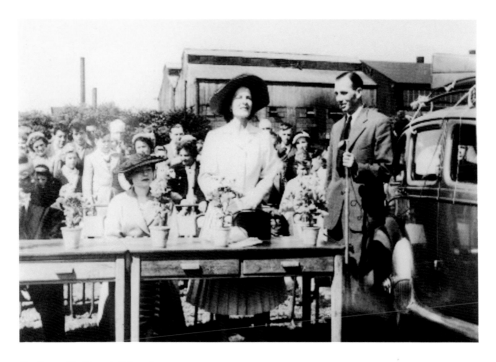

Dartmouth Street School

Dartmouth Street School in the 1950s or 1960s; the lady in the centre of the picture presenting the prizes is the Countess of Shrewsbury. Today the building is occupied by a medical centre but still shows the unmistakable face of an old school.

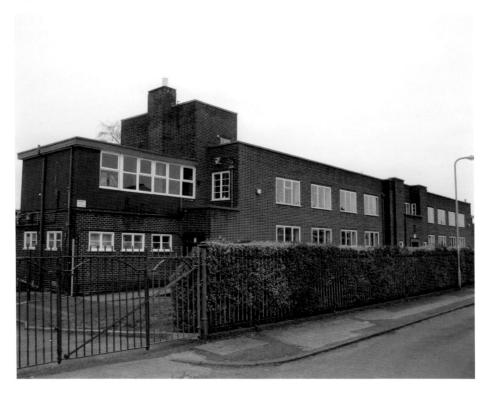

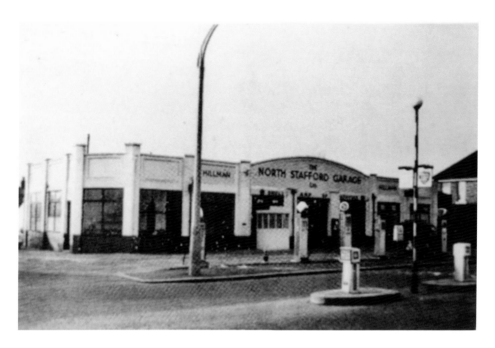

North Stafford Garage

The old North Stafford Garage with the delightful fuel pumps of yesteryear. Later this was replaced by a more modern petrol station, and it is now home to a very efficient team keen to wash any car – even the author's!

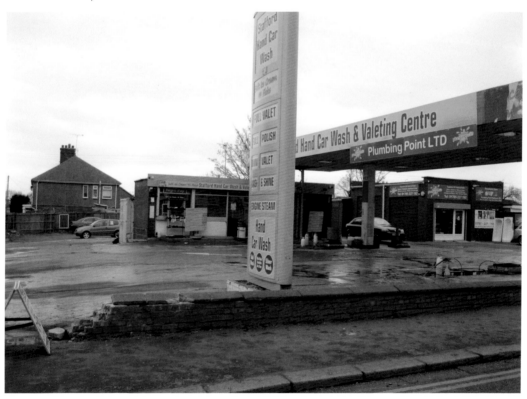

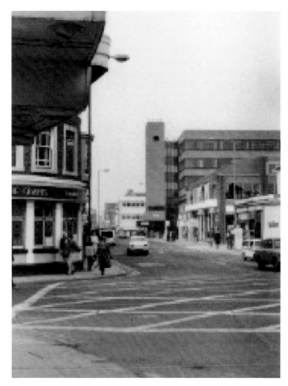

Bridge Street
A photograph of Bridge Street in the late 1960s or early 1970s, taken standing outside the cinema. Today the canopy of the cinema still remains, as does the Grapes public house.

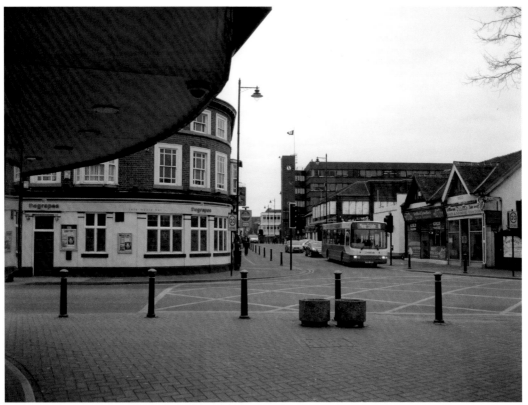

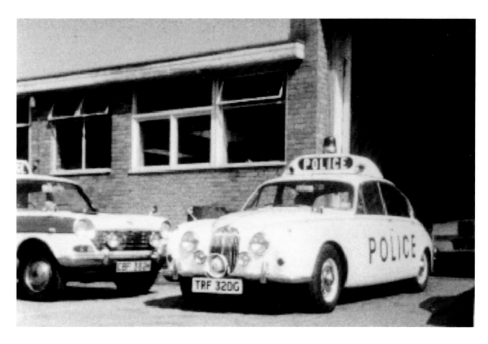

Police Vehicle Workshops
The former workshop for police vehicles was situated towards the far end of Friars Terrace near the corner with Austin Friars.

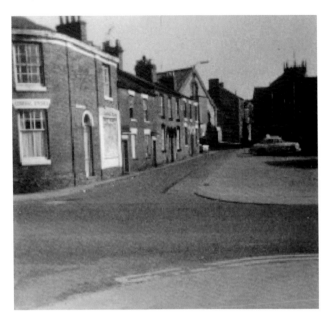

Water Street
The developers have left little
of early Water Street. The older
image appears to have been
taken in the early 1960s, judging
by the car on the right.

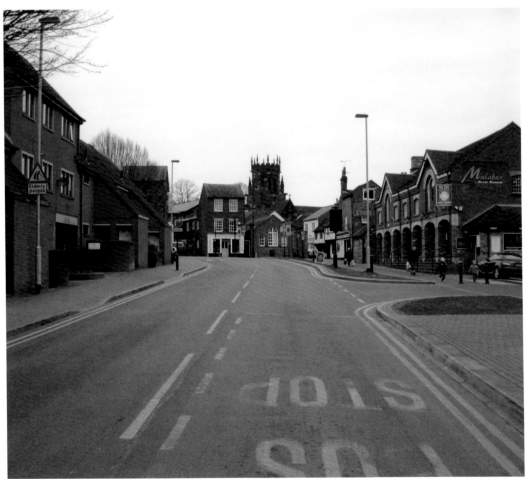

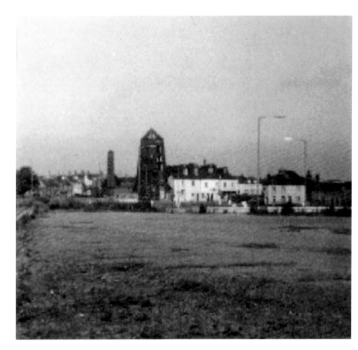

Broad Eye Mill
The old mill itself has changed little over the intervening years, at least on the outside, as can be seen from the adjacent buildings. This is not the case with the surrounding area, which has seen much development.

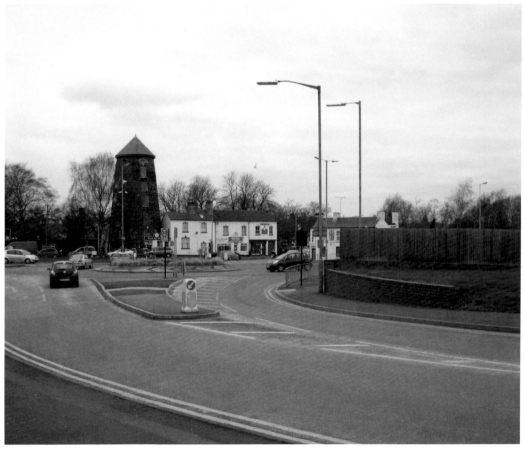

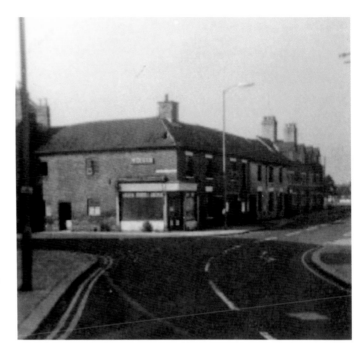

Broad Street
Broad Street, as seen from Stafford Street. Again development has changed the face of a very old Stafford street.

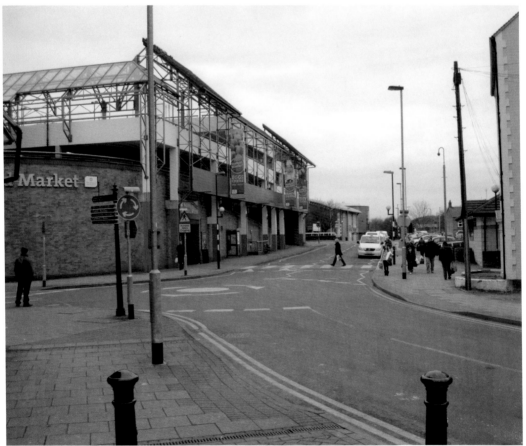

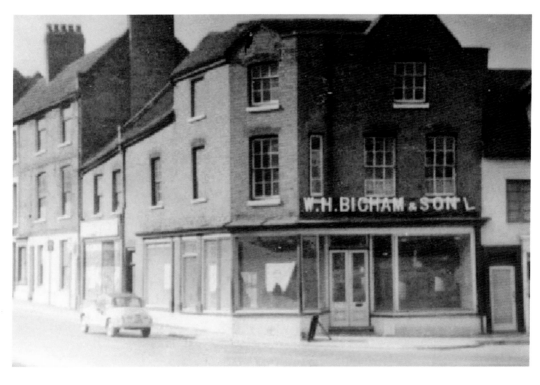

Gaol Square

Many remember with fondness the business premises of W. H. Bigham & Son in Gaol Square, an area that has been completely demolished.

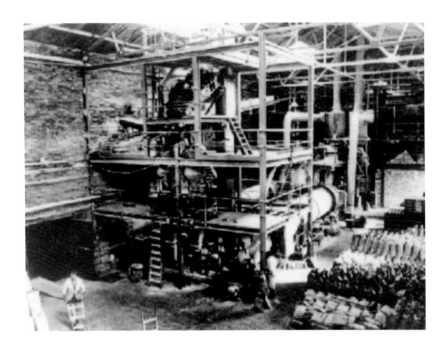

Baswich Salt Works

The interior of the salt works at Baswich is seen in the inset photograph. This was the second factory processing the brine found near Common Railway station; it was pumped to here via the Brine Baths, which became the Royal Brine Baths following the visit of Princess Mary, later queen consort of George V. Today the area has become an industrial estate on one side of the road, while opposite the Saltings residential estate is a reminder of what went before.

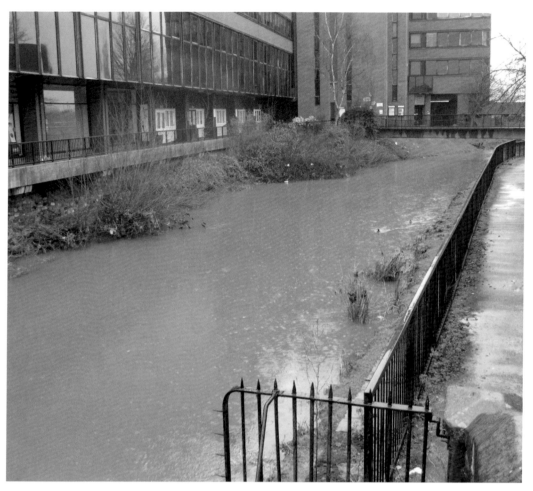

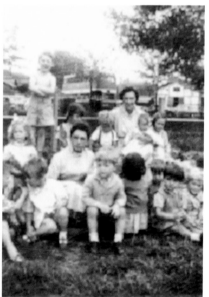

Riverside Day Nurseries
Riverside day nurseries and the children enjoy a
moment outdoors with the staff. A cold February
day on Riverside Walk with the river in spate would
have kept everyone in the warm.

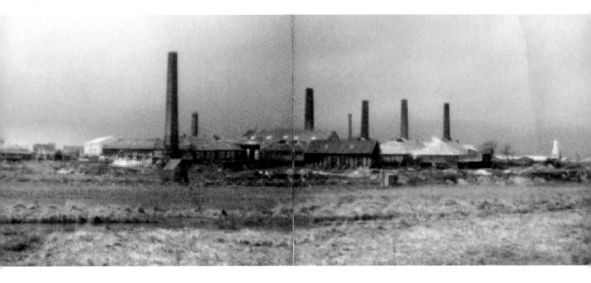

Stafford Salt Works
The Stafford salt works, actually two images that have been spliced together, near the Common Railway station. Salt was worked there until subsidence resulted in a court order winding up operations. As we can see, nothing remains of the old salt works.

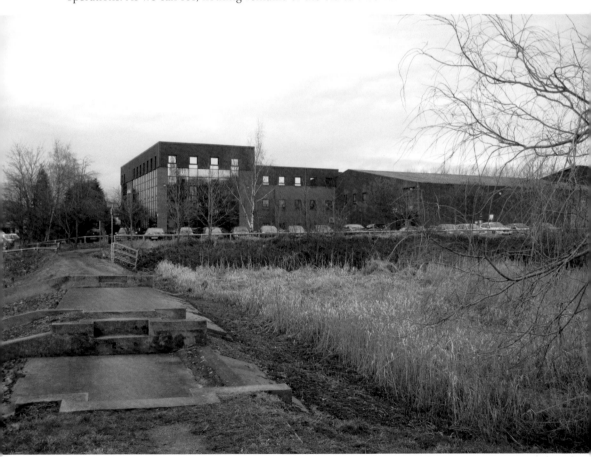

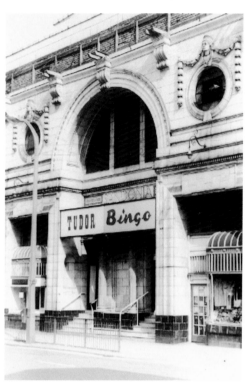

Sandonia Picture House
The frontage of the Sandonia picture house
is still instantly recognisable, albeit rather the
worse for wear in the twenty-first century.

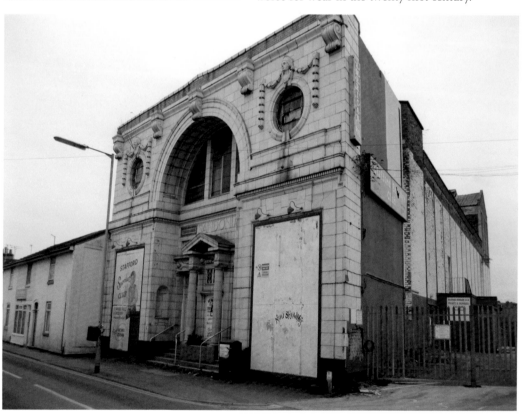

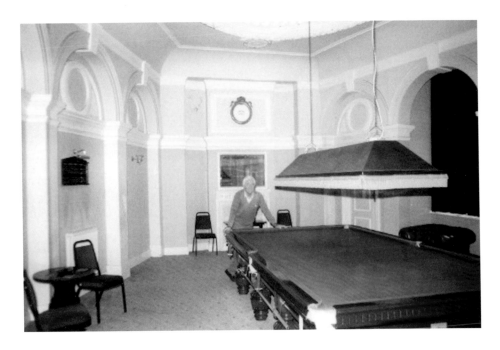

Stafford Snooker Hall

The interior of the Sandonia had seen better days, and from these early images the place is clearly in a very sorry state. However, when the place was utilised as a snooker hall a fresh coat of paint was applied to the rooms in use. Here the upstairs foyer is seen, although behind the scenes little change took place.

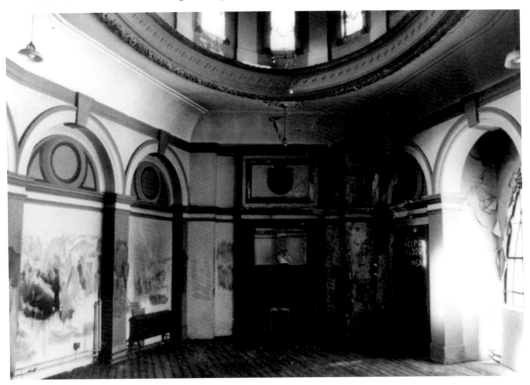

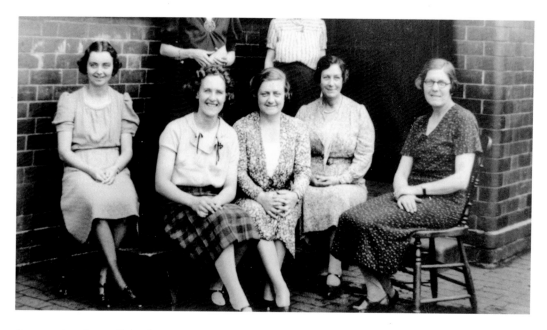

Corporation Street School

Staff of the school in Corporation Street in 1937. Who remembers Miss Hillman and Miss Myco, standing behind, or seated Miss Jones, Miss Barker, Mrs Julian, Miss Martin (headmistress) and Mrs Martin? Today this is known as the John Wheeldon Primary School.

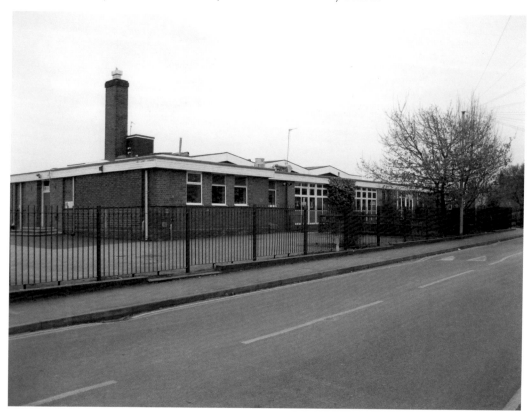